No part of this publication may be reproduced or transmitted in any form or by any means without the prior permission of the publisher. Any copy of this book issued by the publisher as a paperback or hardback is sold subject to the condition that it shall not by way of trade or otherwise be lent, resold, hired out or otherwise circulated without the publishers' prior consent in any form of binding or cover other than which it is published and without a similar condition including these words being imposed on a subsequent purchaser.

The information and images in this book are based on materials supplied to the publisher by the author. While every effort has been made to ensure its accuracy, Pro-actif Communications does not under any circumstances accept responsibility for any errors or omissions. The copyright with regards to all contributions remains with the originator.

© Words and Images 2018 by Sarah Lu

A catalogue record for this book is available from the British Library.

First Edition 2018.

First published in Great Britain in 2018 by
Carpet Bombing Culture.

An imprint of Pro-actif Communications.

www.carpetbombingculture.co.uk

Email: books@carpetbombingculture.co.uk

© Carpet Bombing Culture. Pro-actif Communications.

ISBN: 978-1-908211-53-8

CARPET BOMBING CULTURE

HAND POKED NO ELECTRICITY

STICK 'N' POKE
TATTOO CULTURE

BY... SARAH LU

NO ELECTRICITY HAND POKE TATTS RULE!

PAGES OF THE BOOK

	Page
Introduction by Andy Hobbs	1
Quick Q & A with Sarah Lu (Author and Hand Poke Tattoo Artist)	6
What is a Tattoo?	9
Hand Poke Vs Machine – What's the difference?	11
Dot by Dot / Jab by Jab	15
Flash Designs: For Fun	37
Pain / House of Pain	51
Flash Designs: Bad to the Bone / Skulls	75
Weapon of Choice / Tools of the Trade	79
Flash Designs: Winged Mini-Beasts	99
Under 'Her' Needle – Real life experiences	119
Flash Designs: Animal Skulls	137
Flash Designs: Hand poked Tatts rule!	181
Sarah Lu – Biography	183
Thank You...	184
Get in Touch with Sarah Lu!	188

INTRODUCTION

Everyone has a tattoo these days, right? Once the preserve of the Outsider, the Sailor, the Outlaw biker or the Lag, tattoos have become every day.

Every High Street in every town has at least one tattoo studio. There are thousands of tattooists, turning out work from the sublime to the dog shit. Tattoo studios offer an almost instant personal transformation - walk in one person and walk out feeling and looking like someone new. So seductive is this power that some folk want it now. All of it: full sleeves, back piece, legs, the works. More ink, less skin, job done. Or it was.

Something happened and people started going low-tech. Bored with the production line feel of big, heavy, machined tattoos, a small but savvy number of tattoo enthusiasts were drawn to the tiny hand-poked scene.

Hand-poking wasn't anything new. Since the dawn of time people have been using needles and sticks, whatever comes to hand, to push ink into their skins to make tattoos. With the invention of the electric tattoo machine around the turn of the last century, hand-poking in the West all but fell away. A revived interest in traditional hand working techniques from Polynesia, the Far East and beyond has seen a number of tattooists replicating these methods.

At the same time, there have always been a core of those who simply liked the feel and effect of working by hand. It is here that the heart of the rebellion against machine worked tattoos can be found.

Away from the cul-de-sac of reworked Away from the cul-de-sac of reworked traditionalism, the hand-poking scene was free to experiment and play. As with any accessible medium, the scene's very strength was its weakness - Seemingly anyone could do it. Without a rule book, the D.I.Y. inspired attitude produced a naive style, simplistic when sat alongside machined tattooing but with an undeniable raw appeal than has rapidly gained admirers.

The stripped down look of hand-poking is only part of its allure. In contrast to the big is beautiful aesthetic of electric tattoos,

hand-poked tattoos work well on a small scale, as either standalone pieces or combined in multiples. The 'dot by dot' application of ink, while being slower, lends itself to under-size elements. This gives an illustrative, almost unfinished feel that is the signature note in hand-poking.

There's something about hand-poked work that almost makes you want to frame it and put it on the wall. This pictorial quality brings people into studios seeking designs marked out by tight, angular borders or contained by bare, stark circles. If there's one thing hand-poking does better than any machine, is its isolation. When it wants to be, this thing can be stone cold.

A peculiar upshot of both the precision and self-contained nature of hand-poked work has been an explosion in the mysterious realm of the secret tattoo. People have always hidden tattoos from their Mum and their bosses (a fifteen year old Sarah Lu hid her first tattoo, Green Day in Chinese characters, from her mum), and even though tattooing has never been more accepted than it is now, some folk will always feel like they've got to keep their ink under wraps. Where a little machined piece might seem tacky, the hand-poked tattoo colludes deliciously in its own concealment.

In many ways, the initial success of hand-poked tattoos was a reaction to the over-blown style of modern electric tattooing. No longer a novelty, hand-poking has now become a credible, standalone form within the tattoo family.

At the forefront of this movement stands Sarah Lu, known as 'Needle and Chopstick'.

In stylistic terms hand-poking can be seen in terms of 'Before Sarah Lu' or 'After Sarah Lu'. Sarah has pulled hand-poking screaming and kicking out of its infancy and thrust it into the cold, hard glare of 21st century aesthetics. Whether it's from her background in Graphic Design or her stubborn need to be unfettered, Sarah's work rejects the constraints and limitations that so many place on hand-poking.

Sarah Lu's style is nothing short of an evolution in the helter-skelter world of hand-poking.

Sarah works small but she also goes big, much bigger than most would dare. It's not just a question of scale, it's her lines too, cleaner, crisper and smoother than many thought possible.

One of the more common reactions to seeing her work for the first time is disbelief, "You must've used a machine. That's not hand-poked! " Yet it was all just done with a needle and a chopstick. People often ask why use chopsticks? Do other people do it this way, or is it symbolic of Sarah Lu's cultural heritage? Perhaps the answer is both but the fact that she eats with chopsticks everyday means that she buys 1500 pairs per year. Sarah Lu lives, eats and works with chopsticks, so it's when it's not time for noodle and chopstick then it must be time for 'Needle and Chopstick'.

Sarah Lu revels in the exposed nature of hand working where once the ink is pushed under the skin it's either right or it's wrong. Hand-poking is uniquely unforgiving. One dot out of place can ruin a line. The idea that hand-poking gives the tattooist more control than a machine is only true if the artist has the skill to execute the exact placement of the needle and Sarah Lu has that skill in buckets.

One poke at a time, Sarah achieves effects that are rarely found in hand-poked work. Sarah Lu's needle and chopstick work is always without colour (since childhood, she has always drawn entirely in black ink on paper).

When tattooing, she builds texture using the skin itself to create relief tones in the absence of colour. Sarah's intense and precise needle-work turns on its head the idea that hand-poked work is inherently flat and two-dimensional.

Sarah Lu has brought hand-poking to somewhere where it 'if she can draw it, then she can tattoo it', with just a needle and a chopstick and that is a very exciting place to be.

Andy Hobbs

"KESTREL"
(ACTION PHOTO)

UNFORTUNATELY, THIS PIECE WAS NOT FINISHED IN TIME FOR THE PUBLICATION OF THIS BOOK...

BUT, YOU CAN SEE THE COMPLETED 'KESTREL' TATTOO VIA MY INSTAGRAM, YAY!

SARAH LU

TATTOOING HAS MADE MY RIGHT INDEX FINGER...

'ABNORMALLY LARGE!'

IT'S... HENCH!

IT LOOKS SO STRANGE!

OVER TIME, A CALLUS HAS FORMED OVER THE TIP OF MY FINGER!

+ MY FINGER MUSCLES HAVE ALSO ENLARGED.

A QUICK "Q+A" WITH... THE AUTHOR

How long have you been a professional hand poke tattoo artist for?
Professionally for 4.5 years.

Why hand-poking as opposed to machine tattooing?
A basic drawing tool is a pen. We can create the most amazing artwork (whether it be intricate, bold, beautiful or techincal), simply by how we use this tool to apply the ink to a canvas (paper).

I hand-poke because I am fascinated, excited and challenged by what can be achieved when basic tattooing tools (such as a needle and a chopstick), are used to apply ink to the most interesting canvas that I have ever worked with - The skin.

Do you ever use a tattoo machine in your work?
No - I can't actually use a tattoo machine. I also can't drive... I just don't have that "thing" that enables others to operate machinery! Ha!

Everything that you see in this book is 100% hand-poked with a needle and a chopstick, and powered by just me.

How many tattoos have you done to date?
I have no idea... but definitely over 1000 in my lifetime!

What's the longest amount of hours you have spent on a hand-poked piece?
60+ hours on a full sleeve (including the chest), over 12 sessions.

What's the largest hand-poked piece you have done to date?
I'm not sure, but an example of a large tattoo that I have done spanned from the client's sternum, over his ribs, stomach, hips and thigh, all the way down to above his knee...

What's the longest amount of hours you've tattooed in one sitting?
10 hours in one day... With a few 15 minute breaks of course!

Do your arms and hands not hurt?!
In the beginning, my shoulders and hands ached and hurt a lot and I had to have breaks all of the time! But these days, they don't bother me so much and I can tattoo for ages without stopping.

I guess the strains that you initially put your body and mind through, eventually strengthen, and adapt. Plus your stamina grows!

Do you create all the designs yourself?
Yes, all artwork is my own.

I create random doodles and draw up epic illustrations based upon my own interests, but when it comes to my clients, I will custom design each individual tattoo. Aside from my tattooing, I will spend at least 5 hours a day drawing.

I especially love to draw skeletons, skulls, animals, birds, sea creatures, insects, plants and strange hybrids of all of these.

WHAT IS A TATTOO?

...AND WHY DO WE HAVE THEM?

What is a... Tattoo?

At its most simplistic level a tattoo could be described as a permanent mark, or marks, made on the skin using a sharp implement to deliver pigment into the dermis. This is as true of a modern machined back piece as it was of the marks found on the frozen body of Ötzi the Iceman, whose body was found high up in the Alps.

The earliest tattoos developed from the practice of Scarification. Scars are a permanent mark, which are produced by gouging into the skin. To promote the desired production of Keloid scar tissue, substances such as ash would be smeared into the wound.

The use of different techniques and materials to permanently mark the skin is a journey of experimentation and refinement.

Tattoos are created by pushing the ink or pigment through the outer layer of the skin, known as the epidermis, where it is deposited into the sub-layer, known as the dermis. Ink is trapped and pocketed between the layers of skin like the filling in a sandwich.

It takes real precision to gauge this depth - Too deep and it "blows out" into an ill-defined blobby mess, too shallow and just "falls out," as it is pushed out of the skin like a festering splinter.

Why do we have Tattoos?

There are a number of reasons depending on where and when it was made. If we look again at our Copper Age friend Ötzi, many of his tattoos suggest a medical function as they were made in places where he suffered Rheumatoid Arthritis.

Some cultures used them as a protection against harm and to ward off enemies, whereas others used them to identify your tribe, your hierarchy, status and even defeats. In many cultures they are a ritual rite of passage, and in other cultures tattoos were even used to single out those that had done wrong.

Nowadays, the tattoo is an exterior expression of an internal desire, a signpost to the outside world of what we hold dear. The tattoo is the costume that we never take off.

GETTING TATTOOED BY... MACHINE OR GETTING IT HAND POKED-

...WHAT'S THE DIFFERENCE?

HAND POKING – WHAT'S IT ALL ABOUT?

If the history of tattooing was a twenty-four hour clock, the electric coil tattoo machine made an appearance just as the big hand was inching its way toward midnight. Before 1891 all tattooing was done by hand. Without an electric motor to power the needle through the skin, the grunt needed was provided by muscle power alone.

Hand-pushed or hand-poked are the terms most commonly used to describe the process whereby a point attached to a stick, cane or bone is dipped in ink and forced to pierce the skin. The two terms are often interchangeable and can both relate to two distinct types of 'hand work'.

One method requires the stick to be beaten or tapped into the skin with some sort of mallet. The word tattoo, from the Polynesian word "tatau" is thought by some to come from the sound made by striking of two sticks together. From Borneo, through Samoa and on to New Zealand tattoos are tapped in using a variety of strikers.

The other method relies on the point of the stick being repeatedly jabbed into the skin. While both methods are only as good as the person doing it, this type of hand work is generally thought to be less invasive and more controlled. Some types of this method, such as the traditional Thai method, will need anything up to four people to stretch the skin for the tattooist. In other methods, like the Japanese Tebori, the tattooist holds the skin taut with one hand, forming a bridge like a pool player, thus allowing the rod to move backwards and forwards across the hand.

A global resurgence of interest in hand tattooing has seen traditional techniques being revived but with the use of modern sterile steel needles - it is impossible to sterilise wood, bone and stone. Although in saying that, the use of sterile equipment is almost entirely absent from the stick and poke world of jailhouse tattoos, and most homemade jobs!

"TAT TAT!"
"TATAU"
"TATTOO"

MACHINE Vs HANDPOKED...

One of the best things about being hand-poked is that you haven't had a machine do a number on your peach-like skin. The needle on a machine pierces the skin up to 3000 times per minute. That's 50 stabs every second! Imagine someone manually stabbing your skin at this rate – it's going to leave your skin looking like a bloody teabag.

Hand-poking is a more considered, slower affair - that said, Sarah Lu is the fastest hand-poker that I've seen by a country mile. The hand-poke tattooist has greater control over the individual placement of each poke. The speed, the depth, the angle at which the needle goes in, can all be varied depending on the effect required.

The slower pace and manual labour of hand-poking tends to lean itself towards the production of smaller tattoos, but in all honesty, size and detail is only limited by the perseverance and ambition of the artist.

IS IT HYGIENIC?!

Raw as fuck and dirty as a lifer's sock, you never know just what you might catch from one of these homemade beauties... So, be responsible and make sure you're being tattooed by someone who knows what they are doing!

> "Finding the right tattoo artist was **TOP** priority. I wanted someone whose **ART** I genuinely connected with, after all, it is **GOING TO STAY WITH ME FOR LIFE**.
>
> This is my first tattoo and to be honest, I wasn't aware of 'STICK + POKE' and felt nervous after reading various **HORROR** stories, but my tattoo consultation with Sarah Lu put my mind fully at rest. ☺
>
> **THE ONLY** reason people end up with **INFECTIONS** or **POOR QUALITY** tattoos, is because they go for the '**D.I.Y**' STICK + POKE done from someone's **BEDROOM**!
>
> **WHICH MEANS...**
> ① **NO** TATTOO LICENSE (REQUIRED BY LAW FOR HEALTH & SAFETY + HYGIENE STANDARDS)
> ② **DIRTY NEEDLES**
> ③ AND THEY WERE MOST LIKELY TRAINED FROM A YOUTUBE VID!"

Harvey Padda - (Age 26)
Bromley (South London), UK.
Under 'Her' Needle for 3 hours

DO THEY LOOK DIFFERENT TO MACHINED TATTOOS?

Yes. Hand-poked tattoos have a completely different 'finish' to them. Machine work is much more fluid in its application and therefore the finished aesthetic looks similar to that of painting.

The 'poke by poke' nature of hand-work lends itself to a different type of style and detail. Hand-poked work is often grainier and with a raw quality to it. If I were to describe the difference in aesthetic between the two methods, it would be to present you with a pen illustration from the original book 'Alice in Wonderland', and to put it next to the cover of Disney's full colour, air brushed version on VHS!

DOES IT HURT?!

Come on now... Let's be frank, all tattoos hurt, but because hand-poking is less invasive, there is less trauma. Your skin just isn't as beaten up. While it's still going to hurt, it's an altogether different sensation, less industrial and more humane. The great news is that hand-poked work tends to heal quicker too, as there is very minimal blood... Which means little to no peeling or scabbing!

"**NORMAL** EVERYDAY THINGS THAT ARE **MORE PAINFUL** THAN GETTING A HAND POKED TATTOO:

1. A PAPER **CUT**!
2. STEPPING ON A DRAWING PIN!
3. CATCHING YOURSELF ON A SAFETY PIN/BADGE!
4. A SHAVING **CUT**!
5. CUTTING YOUR FINGER ON A **SMASHED GLASS**!
6. GETTING **PINCHED** REALLY HARD!
7. CARPET BURN: JUST AFTER YOU DO IT, WHEN YOU LOOK + THE SKIN'S **RUBBED** OFF!!
8. I'M A MAN, BUT I RECKON GETTING **WAXED** IS DEFINITELY **WORSE**!"

Simon Wiggins - (Age 30)
Crawley, UK.
Under 'Her' Needle for 15 hours

Dot by Dot Jab by Jab

It's easy to think of hand-poked tattoos as just being a series of dots applied one after another, but that only tells part of the story. The most common misconception is that hand-poked work and the ever-popular 'dotwork' style of tattooing are one and the same.

'Dotwork' is when dots are used to produce shading and various effects, which can be done by hand or machine.

Hand-poking is a technique that can 'only be' applied to the skin in a 'dot by dot', or 'jab by jab' manner... You can't drag the needle across the skin to produce a line like the machine can do, hence why this technique is mistaken as Dot work.

A good and experienced hand-poker will poke the ink into the skin in such a precise manner that clean lines, texture and shading are produced by controlling how tight or loose the groupings of their insertions are.

There's a world of hand-poked tattoos out there, but it's only when you get up close and personal that you can see the quality of the work. Simply put, it's all about the line work. Precise lines, tone and texture are built up from accurately placed dots. An OK tattoo might look good from twenty paces but a great tattoo just gets better the closer in you get, and when the lines are so damn tight, they can often get mistaken for machine work.

Artists globally are on a roller-coaster fast learning curve. Hand-poking has undergone a rapid technical evolution, unshackling from its primal art form, it is developing into something modern and unpredictable.

Hand-poked fans are savvy when it comes to hygiene, quality and longevity. These are people who know what they want and where to get it.

SOLID COLOUR

Produced by having 'no gaps' between each dot.

SHADING

Shading is achieved by placing the dots, either closer together...

...or further apart

Tones, shadows & gradients are produced by clustering the dots.

LINE WORK

Lines are created by 'closing the gap' between each dot.

DOTS RULE

SUPER 'CLEAN' LINES...

...are harder to execute than it looks! It takes precision, discipline, skill & experience, to create the perfectly 'crisp' line-work.

* THIS WAS IZZY'S FIRST EVER TATTOO! WHAT A TROOPER!! AND SHE DIDN'T COMPLAIN ONCE! *

THIS HUGE BACK PIECE TOOK 25 HOURS TO COMPLETE (SPREAD OVER 5 SESSIONS).

"GRIM REAPER"

THIS IS THE 'STENCIL' DESIGN FOR THE 'GRIM REAPER'

THIS 'OUTLINE ONLY' VERSION OF THE ORIGINAL DRAWING IS PRINTED ONTO THE CLIENT'S SKIN, PROVIDING A BASIC GUIDE FOR THE TATTOOIST.

Grim Reaper
The Reaper tattoo is a badge of honour for those who have had a close shave with Death's scythe.

"HUMMING BIRD"

HUMMING BIRD STENCIL DESIGN

EXAMPLE OF WHAT IT WOULD LOOK LIKE ONCE THE SHADING IS ADDED.

Humming Bird
Her tiny heart, beats over a thousand times a minute, her wings eighty times a second. This magical bird was seen as a go-between man and the Gods of the Americas.

"JELLY-CAT"

YES... IT IS HALF JELLY-FISH + HALF CAT!

I OFTEN AM ASKED...

Q: "WHAT DO YOU ENJOY DRAWING THE MOST?"

A: HYBRID ANIMALS!!

SINCE CHILDHOOD, I HAVE BEEN FASCINATED WITH THE MYTHICAL COMBINATION OF TWO ANIMALS. STRANGE I KNOW! BUT I LOVE THE PROBLEM SOLVING OF CREATING AN AESTHETICALLY PLEASING HYBRID OF 2+ ANIMALS.

WHY ON EARTH WOULD SOMEONE WANT A JELLY-CAT TATTOOED ON THEM?!!

CLIENT: "I LOVE YOUR HYBRID ANIMAL DRAWINGS. I LOVE JELLY-FISH. BUT WHAT CAN WE MIX IT WITH?

ME: "DO YOU HAVE A PET?"

CLIENT: "YES I DO. I HAVE A CAT."

JELLY-CAT IS A CALF PIECE
AND IT TOOK 10 HOURS TO COMPLETE.

"GOAT + COMPASS"

Goat
The goat is charged with a dark, and primal sex magic. The horned one, virile and potent was a worthy blood sacrifice given to appease the ancient ones.

This man loves the sea, and he loves his fishing!

His 'sea inspired' sleeve took 25 hours to do...

But, there's still loads more to do. He has space for more tatts, and... the whole sea to dedicate them to!

"SEA CREATURES"
(Bass Chasing Eels)

"BAT"

BAT STENCIL DESIGN

Bat

Bats are our nightmares in leathery flesh. This dark denizen of the air screams his woe and chills our blood. Insanity lurks beneath their wings.

In China the bat brings luck while to the Maya they are the souls of the dead.

In the West the bat has a long association with witchcraft, Macbeth's witches used wool of bat in their spells.

RAVENS + CROWS

"THE SHADOW-DIPPED HARBINGERS OF DEATH"

THESE CARRION BIRDS WERE A POTENT OF GRAVE MISFORTUNE

Raven
In Native American folklore, the Raven is a shape-shifting trickster who plays on man's vanity for his own amusement.

"GOOD MORNING MR. MAGPIE, HOW IS YOUR LADY WIFE?"

Magpie
A member of the 'butcher-bird' family, the Magpie is the bird-lord of superstition, the bearer of doom.

Seeing a group of magpies is said to predict the future, but seeing a lone magpie brings bad luck.

If you show him respect by saluting him in the correct manner, you might just stand a chance of him sparing you from his curse.

"KILLER WHALE"

HAND POKE TATTS RULE!

FLASH DESIGNS

"MINI LANDSCAPES"

THE POISONOUS BEAUTY OF THE 'PEONY' FLOWER

Peony
The Peony flower has a history that dates back thousands of years. It is believed that if the peony bush is in full bloom in your garden during spring, then good fortune lies ahead. On the other hand, if the peony bush looks tired and the flowers are not vibrant in colour, then be prepared for a disaster being on its on its way.

From the outside, the beautifully lush, full, rounded bloom of the peony makes it a deliciously powerful flower, but beneath its mesmerising beauty, is a plant that is truly poisonous if ingested.

"LOST

"SEA"

Compass
The compass tattoo was worn by sailors and adorned on their ships to ensure that they would return home safely. In brutally rough and unforgiving seas, the ships and the men onboard would disappear without a trace. This symbol of navigation, served as a beacon of hope that they would be guided out of the treacherous waters alive.

"ORCA" GEOMETRIC

"HOWLING WOLF"

USING THE SAME STENCIL HERE ARE...
2 DIFFERENT EXAMPLES OF HOW SHADING + TEXTURE CAN CHANGE HOW THE FINISHED PIECE MIGHT LOOK.

Howling Wolf
Brother wolf is the loner, howling his lament at the Moon. He is the beast that beats within our savage breast, padding patiently around our deepest fears.

For many, the wolf conjures up the notion of the spirit animal within. Native American folklore tells of shape-shifters who could transform into wolves. This tattoo is a glimpse of the beast lurking beneath the skin...

"ROSE STEM"

ROSE STEM STENCIL DESIGN

Rose

The story of the rose is one of a symbol that has waxed and waned in popular tattooing.

Forever the eternal feminine, the rose is both delicate and inviting whilst capably defended by its prickly thorns and deep roots. The rose was the original Tramp Stamp, denoting to some sexual ownership by a man or gang but perhaps best understood as badge of sexual freedom.

Once, sailors would wear a single red rose on their chest to remind them of one they'd left behind. Today a black rose stands in memory of those departed.

...IS JUST WEAKNESS

INK LEAVING THE BODY

- Said some smug individual who wasn't having their ribs tattooed at the time.

HOUSE OF PAIN

There is no separating pain from tattooing. It's all about a needle being plunged repeatedly into the skin, and that has just got to hurt.

Most people just see pain as part and parcel of the deal – You have to endure X amount of pain for Y amount of time, and the end result is a great tattoo that gives Z amount of pleasure. End of story.

It's like getting on the ghost train at the funfair - you're supposed to be scared. Blue Dragon Tattoo studio in Brighton, where Sarah Lu works, has a huge sign emblazoned on it's wall that says " No Cry Babies " - An 'in joke' reminder that this is for grown-ups only. (They also have a mandatory £5 fine for whinging!)

"What's the price of beauty?" is a real question in the back, crack and sack wax world that we live in. The answer is pain and usually some considerable expense.

There is an implicit understanding that looking good is going to hurt and we're OK with that. In fact we want others to appreciate our suffering. Part of the aesthetic of body modification, whether it's tattoos, piercings or botox, is that we want others to know just how brave we are and what risks we've taken in pursuit of our goals.

We wear them to show we're hard. The truth is of course that tattoos don't mean that you're tough, though they do mean that you've made some big decisions.

All tattoos are uncomfortable and some are unpleasant, while the rare few are downright disgusting. The good news is that the initial sensation often wears off as you become accustomed to it. As the needles break the skin repeatedly, the receptors send a flurry of signals of to the brain. The brain responds to this prolonged attack by producing endorphins to block out the pain with an added bonus where

everything gets a little dreamy. That helps and it's kinda nice too - a dreamy kind of after-buzz that makes you want to tip your tattooist. This doesn't mean that tattooing is pain-free. Oh no. But if I stick my neck out, I could say that hand-poked work hurts less than machined.

The thing about tattooing that people don't tell you is that most tattoos really don't hurt too badly and everyone really does experience pain differently. I fell asleep having my sternum tattooed but cry when I have earache.

The battle with pain is mostly fought in your head; the more stressed and worried you are the worse it will be. Breathing and music really can help but the best thing that you can do is to go to good artist. A rapport with someone you can trust is the best medicine and they tend not to beat you up too badly either.

People are always asking which parts of the body hurt more. Places with less muscle and fatty tissue like knees, ribs and feet are going to hurt. Areas with greater clusters of nerves like the face, genitals or throat are never going to be easy. Tight skin, muscle mass and body fat all have their part to play too. However they produce different types of pain and we all respond to them in our own ways.

The one thing that can be said is that a skilled hand-poker will hurt less than an amateur tattooist of any strip. Control, speed and the angle of attack will all affect the way you experience your tattoo. Hand precision wins out over the trauma of machined battery and assault but the real difference lies in the hand of the artist and not how the needle meets your skin.

Andy Hobbs

HOUSE OF PAIN
OUCH! OUCH! OUCH!

COLLAR BONE ↓

STERNUM

ARMPIT

RIBS ← NOTORIOUSLY PAINFUL!!

SPINE ←

PAIN IS SUBJECTIVE... BUT THESE TASTY AREAS ARE DEFINITELY ON THE... 'OUCH' LIST!

KNEE CAP
(+ BACK OF KNEE)

SHIN

FOOT

INNER THIGH/
UNDER ARM
(FLABBY SOFT BITS)

ELBOW

+ INNER ELBOW

ON TOP
+ UNDER
NOTORIOUSLY SENSITIVE!

HANDS

BOTH ARE NOTORIOUSLY UNPLEASANT!

LEST WE FORGET...
FACE, ARSE CRACK, EYE, GENITALS... OUCHIES!!!
(OR SO I'VE HEARD!)

"THE MAD HARE"

Hare
The wondrous hare is a creature with pagan, sacred and mystic associations, but most famously, for its mad March courtship rituals.

In British folklore, the hare was recognised as an associate of disaster. Hence, the words: "Hare before, Trouble behind."

"The Camellia Flower"

White because I adore you
Red because I love you
Pink because I miss you

"THE OLD TREE"

Old Twisted Tree
Gnarled roots hold steadfast in the ground. The old tree was here before we came and will remain when we have gone. Beneath its ancient boughs, new life grows.

The old twisted tree stands for strength and durability.

"TUI"

ORIGINAL INITIAL
ROUGH SKETCH
FOR THIS 3/4
UPPER ARM SLEEVE

"Heart Mandala"

"GYPSY SKULL"

Gypsy Skull

'The Gypsy Girl' is a popular traditional tattoo design.

She is often shown looking into the distance, showing that she can see into the future.

A sugar skull design celebrates the Mexican event 'Day of the Dead'. Combined together, they can represent the loss of a loved one.

Endlessly cool and graphically clean, skeletons are the meat puppet laid bare.

Gleaming skulls and bleached bones inked in skin become unconscious talismen against our own mortality.

Nothing screams rebellion louder than a grinning skull.

FLASH DESIGNS

SKULLS

WEAPON OF CHOICE

WEAPON OF CHOICE
TOOLS OF THE TRADE

WILL IT HURT?

The story of tattooing is bound up in the human need to adorn and decorate their bodies. Over 130,000 years ago our close relatives the Neanderthals were wearing items such as polished eagle claws as jewellery. Red ochre found among their grave goods may even have been applied to their skin.

Paints and pastes rub off. A more permanent method of marking the skin is by cutting or piercing with sharp or pointed edges, such as flints or shells developed, a process know as scarification.

These marks could be made more pronounced by putting ash or clay into the wound to encourage the growth of more scar tissue.

The earliest form of tattooing would have been rubbing agents such as soot or vegetable dyes into cuts.

What distinguishes true tattooing from scarification in simple terms is that tattooing is the application of pigment into the sub-layer of the skin, the dermis. To do this you need a tool, an implement to deliver the pigment in a controlled manner.

This section of the book examines a hand picked selection of some of the fearsome devices that people from all over the World and throughout history, have fashioned using the materials around them for just that purpose, inviting you to pick your weapon of choice!

WEAPON OF CHOICE #01. CAVEMAN

Clay palette
Holes filled with ochre paste
Sharpened bone (human? animal?)

The Upper Palaeolithic or Old Stone Age witnessed an explosion of artistic output. Some have linked it to the beginning of language, others to the use of Psychedelic drugs but whatever the reason, from cave walls to pottery, spear throwers to bone flutes, people began to decorate everything.

While we have no direct evidence of tattooing from this time, we have tantalising clues such as figurines incised with elaborate markings. Most compelling of all are the finds from the Pyrenees dating to some time between 38,000 and 10,000 B.C.E. These have been interpreted as being the earliest possible tattoo kit. It's thought that red ochre, often associated with early burial rites was mixed into a paste in the holes in the clay disc and then applied to the skin using sharpened bone quills.

We can only speculate as to why our ancestors would tattoo themselves, whether they were ritual or decorative. The very oldest remains of actual tattoos come a little later from "Ötzi the Iceman" whose frozen remains were found high in Alps. Otzi, had over fifty small tattoos made by rubbing charcoal into small incisions. Many of them were around areas of worn joints and rheumatoid arthritis suggesting that his tattoos had healing or magical significance.

WEAPON OF CHOICE #02.
TEBORI · JAPAN

"HUMAN" ELBOW BONE!

Traditional Tebori tattooing is the only form of tattooing to have been inspired by the illustrations in a book. In eighteenth century Japan, the popular imagination was gripped by the rich woodcut illustrations in a Chinese novel, which showed characters with lavish tattoos.

Such was the demand for these tattoos that the very woodblock cutters who made the images began to use their tools and ink on human skin.

Tebori comes from the Japanese words "Te" meaning hand and "Bori" to carve.

Needles, either singularly or in bundles would be tied to a rod, usually bamboo, horn or in this case a human bone. The needles would then be dipped in ink and pushed into the skin by the tattooist.

Artists sometimes say that the Tebori technique makes the skin talk, releasing a "sha, sha, sha" sound with each thrust of the needle.

Very slow, deliberate and undeniably painful - Tebori is renowned for its beautiful layered shading and crisp finishing.

WEAPON OF CHOICE #03

PRISON TATTS

'TEAR DROPS' ARE ONE OF THE MOST COMMON TATTOOS IN PRISON

POSSIBLE MEANINGS ARE:
- LENGTHY PRISON SENTENCE
- MURDER
- ATTEMPTED MURDER
- SEEKING REVENGE

Hand-poked jailhouse tattoo paraphernalia is an elusive beast. Like homemade shanks and weapons, this stuff was contraband and had to be hidden. In a similar fashion it would be made from whatever came to hand, like toothbrushes, pens and bits of wood. Sewing needles, ground and sharpened metal pins would be tied or fixed to a handle and dipped in prison ink.

Prison ink too could be made from the most unlikely materials such as potato juice mixed with soot or even melted shoes.

Back in 1839 a jail in the seaport town of Yarmouth in England recorded that around 20% of the inmates were tattooed. Notes show us that they used coal and pins to mark themselves, as well as ink stolen from prison classrooms.

WEAPON OF CHOICE #04: SAMOAN

TATTOOED PENIS (ouch!)

TATTOOED ANUS

Samoan tattooing is renowned for the pain and suffering endured by young men receiving the 'Malofie' – The markings of a rite of passage into adulthood, which covered the body from the waist to the knee, covering nearly all the skin, including the penis and the anus.

Those young men unable to complete the often month long process would have to carry the shame for the rest of their lives.

WHACKED INTO YOUR SKIN!

WOULD U RATHER BE TATTOOED BY...

1. SHARPENED BONE?

OR

2. VOLCANIC FLINT?

'SHARPER THAN STEEL!'

← AU

→ SAUSAU (MALLET)

A soot-based ink would be tapped into the skin using a set of combs known as Au and a wooden mallet called a Sausau. The Au comprised of a comb of sharpened bone set into tortoise shell, which was bound to a wooden handle.

In past times, the comb could be made of highly-prized human bone, and occasionally even of local volcanic flint honed to an edge sharper than steel.

WEAPON OF CHOICE #05.
ANCIENT EGYPT

MADE FROM BRONZE

The story of tattooing in ancient Egypt is a story of the feminine. Numerous wall paintings depict women dancers and musicians with tattooed thighs. The preserved remains of female mummies sometimes bear tattoos, often a series of dots and dashes in ecliptic patterns around the pelvic region, relating to the reproductive and erotic aspects of the woman.

Using bronze-tipped needles, the Egyptians also fashioned images of Lotus flowers, cows and the deity "Bes", protector of women and children. One mummy was found with a pair of baboons tattooed on her throat while others have eyes, a talisman against evil tattooed in several places.

So rich and varied is this legacy that Egypt is called by some "the cradle of tattooing". Almost no tattooed male mummies have been found.

DID YOU KNOW... THAT IT WAS BELIEVED THAT TATTOOS PROTECTED YOUR UNBORN CHILD.

TATTOOS ARE FOR WOMEN ONLY

TATTOOS ON THE WOMB AREA ALSO ACTED AS...

- PROTECTION FROM SEXUALLY TRANSMITTED DISEASES

+ ENCOURAGED FERTILITY

WEAPON OF CHOICE #06.
NAGA PEOPLE OF INDIA

CITRUS THORN

BUNDLED FOR WIDTH

The Naga people of North East India and Myanmar are renowned for their ferocity and independent spirit.

In days gone by, the Naga would take their foes' heads in battle, though it's worth remembering that this practice has only come to an end in recent living memory. Warriors returning with a head would take it to the village Skull House where it would take its place alongside the tribe's other gruesome trophies. The warrior would then be rewarded with prestigious tattoos on his face and chest.

The Naga hand-tap their tattoos using a citrus thorn set into a cane and a mallet. For larger areas, as many as a dozen thorns would be used in a bundle. Ink would be made from extracts taken from trees or fruit, which would then be burnt, and the resulting soot mixed with rice beer.

Both men and women would be tattooed. Some tattoos were sacred, while others gave protection against the evil eye. Tattoos were also given to mark rites of passage such as puberty or childbirth, and girls would receive their first tattoos as young six years old.

WEAPON OF CHOICE #07.
MAORI

Imagine this beast → sinking it's teeth into you!

With it's razor sharp TEETH!

The traditional Maori Uhi differs from most tattoo implements of points or needles, and instead they have an edge. Chisel or knife-shaped pieces of Albatross bone, stone or even razor-sharp shark's teeth would be set into an ornate wooden hasp.

A tattooist would typically have a set of Uhi of varying thickness as well a short wooden mallet used to strike them.

In ancestral times, the tattooing of a Chief's daughter would be marked by a human sacrifice. The victim would usually be a member of a neighbouring tribe who had been captured in a raid. They would be cooked and eaten in a great feast.

This practice gave rise to a chilling traditional taunt - " You are a person of no account whatsoever. Your ancestor was slain and eaten for the tattooing of my grandmother!"

WEAPON OF CHOICE #08.
DAYAK PEOPLE OF BORNEO

THIS SHARP **IRON** SPIKE IS HAMMERED INTO YOUR SKIN!

For the Dayak people of Borneo, tattoos fulfil a number of crucial roles. In a world filled with spirits, good and bad, they can offer protection against those who would wish you ill. A potent concoction of charcoal, animal bones or even meteorite added to the ink, would be specifically chosen for their magical properties.

Tattoos could protect you from physical harm too; on the neck they could prevent enemies from chopping off your head. As well as marking achievements such as childbirth or the taking of a foe's head, tattoos act as a sort of passport to afterlife, allowing you to move from this world to the next.

Traditional Borneo tattooing differs from other hand-tapped methods by the way the tattoo is first marked out on skin. The intended design is gouged into a wooden block, which is smeared with ink and then pressed onto the skin, creating a stencil for the tattooist to follow.

Borneo tattooists, like with other cultures, work with two sticks – One stick holds needle points set in resin and dipped in ink, whilst the other is used as a mallet to forcibly penetrate the skin. Although bamboo splinters were used in the distant past, iron spikes are more common in recent times.

WEAPON OF CHOICE #09.

CANADIAN ARCTIC INUIT

A SEWING NEEDLE...

...USED FOR MORE THAN JUST TO DARN YOUR CLOTHES!

Traditional Inuit tattooing takes its inspiration from the skin stitching techniques used to join skins together to make, and to decorate the parkas, boots and blankets essential for survival in the Arctic Circle.

Older women, accomplished embroiderers were the tattooists who would mark younger women to show that they had come of age. In days gone by, a bone or wooden needle was used to pull a thread of whale sinew dipped in a mixture of soot, urine and graphite through the skin. Held in place by a wooden toggle, the thread was left to dissolve in the skin. Urine was dabbed on the thread to aid its breakdown until all that was left was the pattern made by the stitches. The arrival of Europeans practically wiped out skin stitching among the Inuit. The discovery of several mummies in Greenland in the seventies, still bearing their threaded tattoos after five hundred years, heralded a revival of this human embroidery.

Steel needles, cotton and tattoo ink, are now being used in this unique practice.

WEAPON OF CHOICE #10.
STICK 'N' POKE

JUST A NEEDLE...

...AND A HUMAN HAND!

In today's modern world of hand-poked tattoos, many cultures have kept alive their traditions using tools familiar to their ancestors. While some still use tools unchanged by time, most tools have evolved with the access to new materials and manufacturing. A deeper understanding of pathogens and cross-contamination means that most people now rely on disposable, sterile needles. The principles however, remain the same.

Ink is simply carved or 'whacked' into skin with the precision, discipline, and Craftsmanship of the human hand. It is an endless wonder, that a human being can control these tools to produce such beautiful markings on the skin, without the aid of electricity or modern technology.

'Stick and Poke', is simply what it is. Ink is poked into the skin dot by dot, by pushing the needle into the skin in a controlled manner. In other methods of tattooing by hand, a mallet is used to force the ink into the skin. Stick and poke does not. In the absence of a mallet, the only power driving the needle into the skin is the human hand.

I am Sarah Lu, and I simply bind together a disposable wooden chopstick to a sterile, single-use, stainless steel tattoo needle. Some use simply just the needle, whereas others may attach it to a wooden or metal stick for more control.

"Flash Designs"

"Winged Mini-Beasts"

SCARAB BEETLE

BUMBLE BEE

LADYBIRD

DRAGONFLY

RHINOCEROS
BEETLE

FLYING
ANT

"GEOMETRIC LAYERS"

"FEATHER"

"THE LEPIDOPTEROSA"

(HALF MOTH, HALF ROSE)

(HALF SHARK, HALF SWALLOW)

A 'SHALLOW'

"OCTO-HUMMINGBIRD"
(HALF OCTOPUS, HALF HUMMINGBIRD)

THE MONSTROUS DEMON OF THE SEA

"OCTOPUS"

DON'T BE SUCH A CHICKEN
- GROW SOME BALLS!

"COCK" OF THE WALK

"DOG + TREE"

(FREE-HAND) "SHELL"

THIS TATTOO WAS 'FREE-HANDED' DIRECTLY ONTO THE CLIENT — <u>NO</u> STENCIL!

I SIMPLY HAD THE 'SHELL' ON A TABLE + TATTOOED IT AS A 'STILL-LIFE' PROJECT / EXPERIMENT.

GOING UNDER ~~THE~~ 'HER' NEET

LIE

'REAL LIFE' EXPERIENCES

ON A SCALE OF 1-10... HOW PAINFUL WAS IT?

Come the day of my tattoo appointment, I was feeling quite nervous about the pain. I had of course done some online research, which told me the procedure would be more painful than using a machine.

The reality couldn't have been more opposite! The pain was minor, it was almost therapeutic and I found myself close to dozing off.

I would say the pain was 2 out of 10, with 10 being the worst. The pain is similar to someone pushing their nails into your skin.

CASE STUDY 01:
Harvey Padda - (Age 26)
Bromley (South London), UK.
Under 'Her' Needle for 3 hours

UNDER 'HER' NEEDLE

IT FEELS LIKE SOMEONE ...IS 'PUSHING' THEIR NAILS INTO YOUR SKIN

UNDER 'HER' NEEDLE

FEELS LIKE YOU'RE BEING PLUCKED

UNDER 'HER' NEEDLE

BITING SENSATION

"THE ANTICIPATION OF THE PAIN.... IS FAR WORSE THAN THE ACTUAL TATTOO..."

My first and only tattoo was hand-poked by Sarah Lu. Admittedly, my tattoo is very small and only took a few minutes - I might be writing something different if it was bigger and I was there for an hour - but I would liken the pain to that of having your eyebrows plucked. A quick biting sensation that is more irritating than painful, yet becomes strangely addictive. The great thing with hand-poked tattoo's is the lack of buzzing that you hear when people are tattooed (on TV!) and this was definitely a plus for me.

CASE STUDY 02:
Nikki Leach - (Age 35)
Eastbourne, UK.
Under 'Her' Needle for 15 minutes

I WONDERED... "HOW HARD WILL SHE HAVE TO DIG INTO MY SKIN... TO GET THE INK TO STICK?!"

A bygone age whereby people were being tattooed by hand and the history and traditions behind it all fascinates me.

Once I had decided to get a hand-poked tattoo, I started to do some research on hand-poke artists from all over the world, and found articles about Sarah Lu's work on Tattoodo.com. Theses were called "10 Hand-Poke artists you should really get to know", and "Dark and Beautiful hand-poke tattoos by Sarah Lu".

I was immediately drawn to her work - My first impression of her tattoos was that every tattoo had an atmosphere and an epic story behind it.

Before my tattoo session with Sarah Lu, I thought that it might hurt slightly more than a machined tattoo because I wasn't sure how hard she would have to dig into my skin to get the ink to stick. I heard that the ink doesn't stay in the skin as well as machine tattoo – I was 100% WRONG!

Personally, the pain of getting a hand-poked tattoo was nowhere near as bad as I thought it would be. It's like when you accidentally prick yourself with a sewing needle or a safety pin.

UNDER 'HER' NEEDLE

IT FEELS LIKE...

...PRICKING YOURSELF WITH A SEWING NEEDLE!

Obviously some parts of the body are more sensitive than others, but after 10-15 minutes the pain sort of fades away and you get used to it.

If I was to compare the two different methods I would have to say that machine tattoos hurt more than hand-poked tattoos, 100%. I think that the added vibrations of the machine definitely contribute to making it more painful. Especially when you get a bony area, where the skin is quite thin.

Hand-poked tattoos just look special, a combination of the artist and the hand poked method gives the tattoo a rugged and earthy impression that makes them deeply personal.

Hindsight is a luxury, but I wish I could go back and start getting tattooed again. They would all be hand-poked!

CASE STUDY 03:
Simon Wiggins - (Age 30)
Crawley, UK.
Under 'Her' Needle for 15 hours

UNDER 'HER' NEEDLE
IT FEELS LIKE A
CAT SCRATCHING

I have a lot of tattoos. All of them have been done by machine but I decided that I wanted to experience something new this time. I didn't know what to expect when I came in for my 'hand-poked' tattoo session with Sarah Lu. I was nervous, which may seem quite silly, as I have already had so many over the years.

During the tattoo session (I think on everyone's lunch break), there was a moment when it was just her and me. The music was playing but there wasn't the buzzing sound of loads of tattoo machines in the room. I listened closely, and I could hear a tiny popping noise as the needle was quickly jabbed and pulled out of my skin. I could hear every dot.

Overall, I found that it hurt less than a machine, and I was quite surprised that it was more annoying than painful! Imagine the feeling of being scratched by a tiny cat, over and over, and over again.

CASE STUDY 04:
Benjamin Haus - (Age 31)
New York, USA.
Under 'Her' Needle for 90 minutes

"...IT WAS MORE ANNOYING THAN PAINFUL!"

I've been thinking about getting a tattoo since I was a student – so at least 25 years. But for whatever reason I never quite had the determination to actually do it. I think I wanted a tattoo to mean something and when you're younger much of what is important to you changes so quickly that it's hard to keep up with your own mind and intentions. A few years ago I started meditating, and I wanted a tattoo to remind me of a significant experience that I had during this time.

I first heard about 'hand-poking' when a friend and her daughter got tattooed in this way. There was something really appealing about the idea of tattoos being hand drawn onto the skin. It seems to me that tattoos are a craft as much as art – you need to know what you are doing with your tools to make something really beautiful. Also I think the style of hand-poked tattoos seem to be more detailed and more individual. Maybe that's just my impression.

The actual tattoo session was amazing. I was nervous beforehand about whether it would be painful – despite Sarah Lu's reassurances. I was full of adrenaline and excitement. I wasn't quite sure what the tools would look like, or what the tattoo environment would be like, or how I would feel.

I could see that her tools were chopsticks with needles attached. I don't know why but I just find that simplicity really reassuring. We talked about the fact that humans have been tattooing each other and themselves in this way since pre-history.

The actual experience was weirdly relaxing. It was like very tiny prickles - I'd say miles less painful than stinging nettles, and a million times less painful than something like having your legs waxed.

I could hear this slight clicking sound, like someone knitting really fast with small knitting needles. It took about two hours to do the tattoo and it passed really quickly.

The experience of being 'poked' with the needles was quite stimulating – My whole body felt very 'alive'. Then after a while I went into this quite trance-like state. It was weird but enjoyable.

I absolutely LOVE my dragonfly. I think it is so stunning. I can't stop looking at it. It's so beautiful.

CASE STUDY 05:
Tamsin Bishton - (Age 45)
Brighton, UK.
Under 'Her' Needle for 2 hours

UNDER 'HER' NEEDLE
YOU CAN HEAR
POP! POP POP!
EVERY SINGLE DOT

I already have a few machine tattoos and so I really liked the idea of being tattooed by a really old school method. With tattoos dating back thousands of years there was almost something a bit rugged or romantic about having one done without electricity in a style that was more in line with "original" tattooing.

When going in to get my first stick and poke I didn't give too much thought to how it would feel. I often forget about the pain of getting a tattoo until I'm actually getting one. Although because of what others had told me I had given it a little thought. I guess I imagined it would feel similar to someone lightly stabbing me over and over again with a sharp cocktail stick?

People often say to me they couldn't get a tattoo because they're afraid of needles. I'm not the biggest fan of needles either but I never really correlated tattoos with them. Machine tattoos come with more of a burning sensation, as if someone is dragging a blunt knife across the top of your skin. It's less of a smooth incision, and more of a rough tear. However, after getting this stick and poke I can see why those who are afraid of needles may be a little more put off by this method. It's essentially like having a much more shallow injection with a thicker needle.

I found it hurt less than with a gun, probably because there is less dragging involved. You can actually feel the regular, repetitive puncturing of the skin rather than having the consistent pain that comes with machine tattoos piercing your skin at a much faster rate.

As for the sound, I found it to be like a strange popping noise. Almost like the impression that humans do for fish as they blow out bubbles being listened to through a silencer. With a machine the buzz drowns out any sound the needle is making on the skin but with stick and poke you obviously just have the needle puncturing the skin. It's quiet, but still audible. You just get a quiet "pop" as the skin is pierced.

The pain you experience post-tattoo is similar, but not the same, to the feeling of a machine tattoo. It feels like a slightly sharper stinging sensation opposed to the strange ache/graze/burn sensation you get with a machine. In spite of the pain though, which is inevitable after getting any tattoo, I'm really happy with the end result. The lines look great though, they're really well defined and bold and I couldn't be happier with the result. I'm definitely glad I chose to get it done with this method over a machine and I'll definitely be getting more.

CASE STUDY 06:
Luke Willis - (Age 24)
Hove, UK.
Under 'Her' Needle for 30 minutes

"HOW PAINFUL IS IT?! IS IT WORSE THAN ELECTRIC TATTOOS?"

...Is easily the question that I get asked the most when I proudly evangelise to anyone (with the patience to) want to hear about my no electricity hand-poked full sleeve shoulder and chest piece.

It's not an easy question to answer, but having had electric tattoos, and having experienced over 60 hours of being hand-poked, I pretty much know the answer, and it's this:

If Sarah Lu and an artist using an electric machine tattooed an identical line, the electric line would in all honesty probably hurt more. However when it comes to shading, the hand-poking is more focused on the same area for a lot longer. So the pain steadily builds in waves in that specific area, until it feels like you're rubbing your skin raw. Plus, it doesn't stop when the needle stops, unlike electric tattoos. Just like when you were a kid getting over the next door neighbour's garden wall to get your ball back and catching the inside of your leg on the brickwork. It's a different pain, but the pay off in the lack of healing time with minimal to none scabbing (that you would normally get with machine tattoo), is a genuine blessing. Don't be fooled - All tattoos hurt.

The sound of Sarah Lu's needle and chopstick is a unique one, and after a while can become quite 'Tantric'. The constant clicking or popping sound can and has, on more than one occasion, sent me off to sleep, which believe me can be quite a unique experience. The sounds can also remind me at times almost of a metronome, which is much more comforting to my consciousness than the electric tattooing that sounds like 100 wasps trapped in a jar.

I do find that the constant steady plucking or picking does allow you to send your consciousness elsewhere which is particularly handy on hour 5 of a 6 hour session.

CASE STUDY 07:
John Donnelly
Southampton, UK.
Under 'Her' Needle for 60 hours

FYI: THIS IS NOT A TYPO ERROR! THIS PIECE TOOK 60 HOURS TO COMPLETE BETWEEN 24/06/16 TO 10/06/17

THE 'CLICKING OR POPPING' SOUND OF HAND POKING IS MUCH MORE COMFORTING THAN THE NOISE OF...

BUZZ BUZZ BUZZ BUZZ

...100 WASPS TRAPPED IN A JAR

"RAM'S SKULL"

With its thick, curling horns + long, narrow face, this beast's **POWERFUL SKULL** is a symbol of **DEATH + SACRIFICE**.

"SLOBSTER"

(HALF SNAIL, HALF LOBSTER)

"TRISTEGOCERATOPS"

Pronunciation: Try-steg-o-sera-tops

(HALF TRICERATOPS, HALF STEGOSAURUS)

THIS HALF SLEEVE
WAS INSPIRED BY
MY ORIGINAL DRAWING:

"STAG
+ RAM'S SKULL"

"STAG + RAM'S SKULL"

Stag
Nothing says old-fashioned masculinity like the stag. King of the forest, this animal represents virility and lust. With his broad spread of antlers, the stag is both a lover and a fighter.

"IBERIAN LYNX"

INITIAL ROUGH DRAWING OF THE LYNX'S HEAD

STENCIL CREATED BY TRACING THE OUTLINE OF THE INITIAL DRAWING

FRIDA KAHLO'S "WOUNDED DEER"

STENCIL DESIGN BASED ON THE FAMOUS PAINTING BY SPANISH ARTIST FRIDA KAHLO.

Wounded Deer – By Frida Kahlo
The Wounded Deer is Frida Kahlo's stark and unconventional attempt to interrogate her vulnerability. Her unmistakable face is planted onto the body of a little deer whose body is pierced with arrows. The dominant image is one that plays with the notion of mythical part-human, part animal creatures and the classical martyr. Innocence and humanity are sometimes best understood by looking to the fantastic and bizarre.

This upper arm piece took 10 hours to complete.

"FANTAIL BIRD"

+ TEA TREE FLOWER

"JELLYFISH"

Jellyfish
The gossamer ghost from under the waves holds a strange attraction for Japanese horror fans. Its poison-tipped tendrils beckon us to its mysterious realm.

JAPANESE INSPIRED "KOI-FISH"

THIS TRADITIONAL JAPANESE INSPIRED TATTOO TOOK 35 HOURS TO COMPLETE!

Koi Fish
The many coloured Koi was a symbol of protection, often worn by the rakish and daring firemen of the Edo period Japan. The different colours and patterns on the fish each held their own special meaning.

Traditional Japanese Art
Japanese tattoos have been present in the West since the nineteenth century when sailors returning from Japan brought their traditional Irezumi tattoos to the public's attention. They rapidly became the height of fashion among European royalty with King George V of Britain among those tattooed by a Japanese artist. Servicemen stationed in Japan after the war rekindled an interest that remains to this day.

"SKULL BEE"

+ OTHER BEES

Bees
The bee is a magical creature, creating golden honeycombs dripping with the promise of plenty. The royal insignia of the early pharaohs, the bee has a long held association with immortality and resurrection.

The bee and the skull combine to create a potent charm against Death's cold sting.

"WOLF-HEAD MANDALA"

STENCIL DESIGN

PART-FINISHED DRAWING TO SHOW HOW THE TATTOO WILL LOOK ONCE THE SHADING + TEXTURE IS ADDED.

Wolves
Wolves represent our primal selves, harking back to a time when early humans and wolves formed an alliance to hunt and live together. The wolf is our untamed spirit, wild and snarling.

TATTOOS FROM MY...
"MISSING TEETH"
RANGE OF CHARACTERS.

I'VE DESIGNED LOADS OF THEM, AND THEY ALL NEED GOOD HOMES!

"ALICE
+ THE MAD HATTER"

"THE DEATH CARD"

NO ELECTRICITY

"BEGGING BONES" (PURGATORY)

173

"BLEEDING HEART"

"DARWIN'S MOTH"

TIME NEVER STOPS

OH, UNFORGIVING "DECAYING CLOCK"

THE AUTHOR SARAH LU

Sarah Lu's arrival in this world was far from auspicious. The daughter of Vietnamese Boat People, Sarah was born in a refugee camp in Lincolnshire in England in 1980.

Once Sarah Lu discovered drawing, it was as if she had been possessed. A quiet child, she spent much of her time on her own doodling whatever came out of her head. Being left alone with a pen and paper, she would often illustrate characters and beings that were subjected to elaborate and sinister tortures. Withdrawing into her own private world she would churn out reams of complex cityscapes populated by macabre hybrid monsters.

After a career in Graphic Design and Advertising that spanned over 15 years, Sarah Lu decided that it was time to reunite with her dark side (her illustration work). A self-taught hand-poke tattooist, she was finally ready to unleash her drawings unto the world and make a permanent mark on those that would allow her to.

A pathological aversion to all mechanical devices, a creative brain that never stops churning, and an inherit need to always eat with chopsticks, ultimately fused themselves together – The end result, is Sarah Lu's very own needle and chopstick method of hand-poked, no electricity tattooing.

Sarah Lu has tattooed all over the world including Australia, New Zealand, New York (U.S.A.), Peru, Paris (France), and is back home in Brighton (U.K.) as resident tattooist at the award-winning Blue Dragon Tattoo Studio (the longest established tattoo shop in Brighton since 1989).

Sarah Lu a.k.a. Needle and Chopstick's work has redefined the art of hand worked tattoos, pulling it into extraordinary and unexpected directions. Moving with a fluid grace between styles, Sarah Lu's dark and beautiful work continues to evolve and provoke, challenging received wisdom on what can happen when skin and ink collide.

After a day of tattooing clients, Sarah Lu can be found at home glued to her drawing desk, in perfect harmony with her husband "Grumpy_barber", who is equally glued to his video games.

I am proud to introduce...

ANDY HOBBS
(ASSISTANT WRITER)

Andy Hobbs is a writer, comedian and campaigner against homelessness. Andy spent fifteen years at the forefront of the international piercing and tattoo industry with the groundbreaking Wildcat crew.

His deep interest in tattooing grew from his work, which brought him into regular contact with many of the world's leading artists. Andy also claims the dubious record of having been up close with more women's belly buttons than any man alive.

Andy lives by the sea with his wife and an impossibly noisy cat.

THANK YOU!

To those that have been patient enough to endure me being an unsociable hermit for the past 12 months that I've spent concentrating on this book.

To my friends and family for believing in me, and for supporting me in all my creative endeavours.

To my wonderful colleagues, and fellow artists at Blue Dragon Tattoo studio, who push me as an artist and tattooist everyday.

To my amazing husband, who is constantly left on his own whilst I'm meticulously dotting away, hour by hour, day by day and night by night.

To Carpet Bombing Culture for publishing my work... and especially to Gary Shove for putting up with the madness that is me.

Thank you so so much to every single person that has ever given me the opportunity to jab ink into their skin! My clients are AWESOME!!!

And the biggest thank you goes to Andy Hobbs (Big Bear), who without his support, dedication and fantastic talent to orchestrate my ramblings into beautifully written words, this book would not have been possible.

Love to you all. x

MUM,
THANK-YOU SO MUCH
FOR BULK-BUYING
ALL OF THE...

CHOPSTIX

FOR ME TO TATTOO WITH!
x ♡ x

MY SISTER DREW THIS

DATE THURSDAY 2ND FEBRUARY 2017
DAY 25

DATE FRIDAAAY 3RD FEBRUARY ALREA
DAY 26

THIS BOOK IS DEDICATED TO
MY BROTHER + SISTER... XXX

GET IN TOUCH!

SARAHLU.COM

(A.K.A)
"NEEDLE AND CHOPSTICK"